D0151140

The Joy of
PARENTING

TODDLERS TO TEENAGERS
FROM THE CLASSIC MAGAZINE ERA

PRION

IN ASSOCIATION WITH **THE ADVERTISING ARCHIVES**

First published in 2000 by
Prion Books Limited
Imperial Works
Perren Street
London NW5 3ED
www.prionbooks.com

ISBN 1-85375-421-8

All images courtesy of The Advertising Archives, London
Many thanks to Suzanne, Alison and Emma
Printed and bound in China by Leo Paper Products Ltd

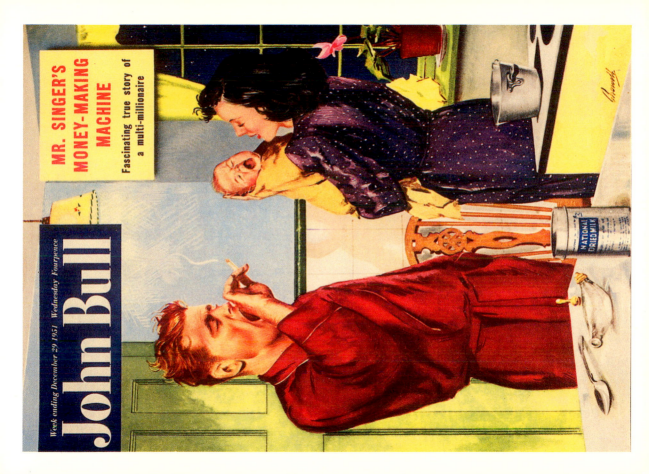

MR. SINGER'S
MONEY-MAKING
MACHINE

Fascinating true story of
a multi-millionaire

Week ending December 29 1951 Wednesday Fourpence

John Bull

NATIONAL DRIED MILK

THE JOY OF PARENTING TODDLERS TO TEENAGERS FROM THE CLASSIC MAGAZINE ERA
PRION BOOKS LTD Imperial Works, Perren Street, London NW5 3ED www.prionbooks.com

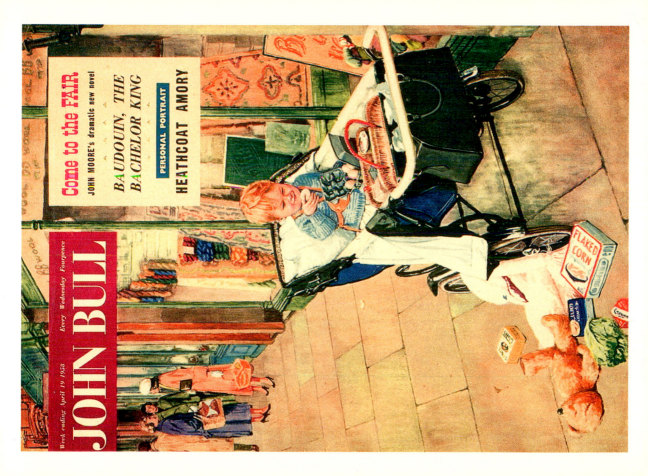

PRION

THE JOY OF PARENTING TODDLERS TO TEENAGERS FROM THE CLASSIC MAGAZINE ERA
Prion Books Ltd Imperial Works, Perren Street, London NW5 3ED www.prionbooks.com

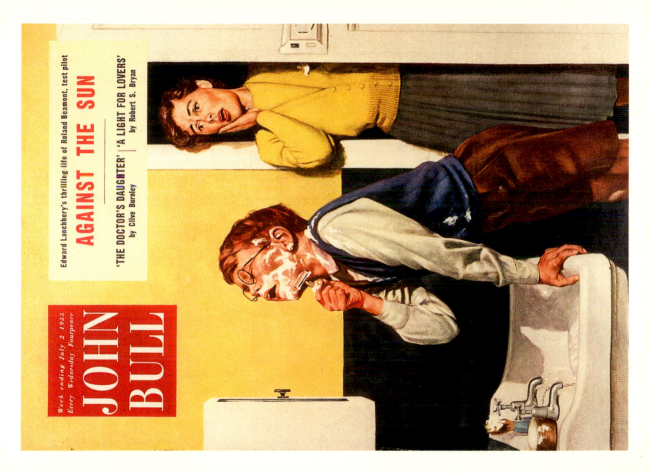

Edward Lanchbery's thrilling life of Roland Beamont, test pilot

AGAINST THE SUN

'THE DOCTOR'S DAUGHTER' | 'A LIGHT FOR LOVERS'
by Clive Burnley | by Robert S. Bryan

Week ending July 2 1955
Every Wednesday Fourpence

JOHN BULL

THE JOY OF PARENTING TODDLERS TO TEENAGERS FROM THE CLASSIC MAGAZINE ERA
PRION BOOKS LTD Imperial Works, Perren Street, London NW5 3ED www.prionbooks.com

PRION

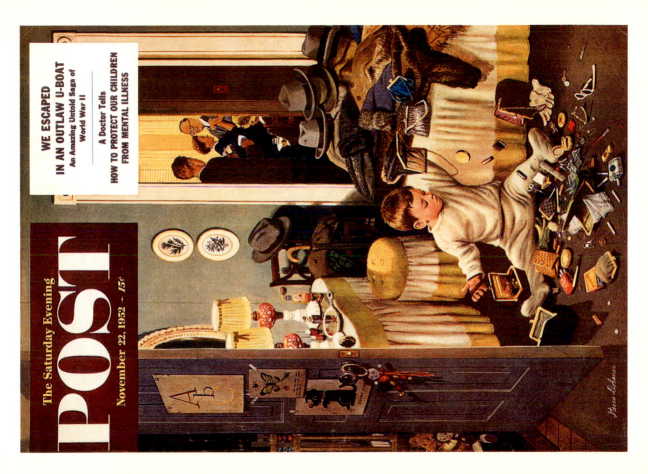

PRION

THE JOY OF PARENTING TODDLERS TO TEENAGERS FROM THE CLASSIC MAGAZINE ERA
Prion Books Ltd Imperial Works, Perren Street, London NW5 3ED www.prionbooks.com

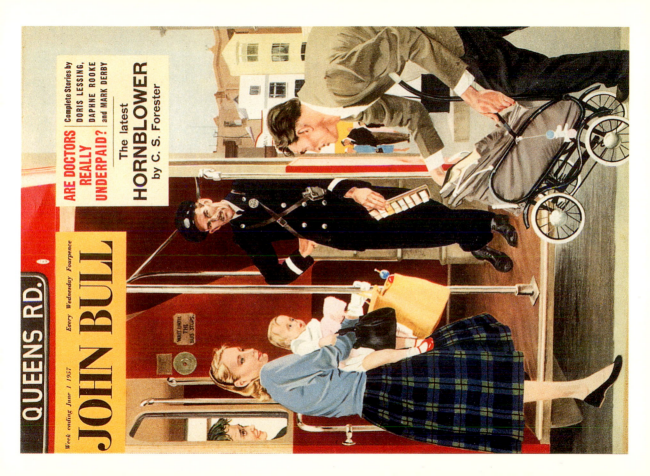

THE JOY OF PARENTING TODDLERS TO TEENAGERS FROM THE CLASSIC MAGAZINE ERA
PRION BOOKS LTD Imperial Works, Perren Street, London NW5 3ED www.prionbooks.com

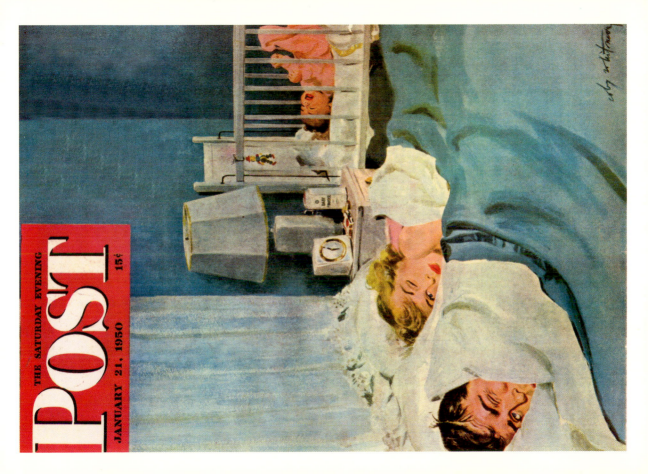

THE SATURDAY EVENING

POST

JANUARY 21, 1950 15¢

PRION

THE JOY OF PARENTING TODDLERS TO TEENAGERS FROM THE CLASSIC MAGAZINE ERA
PRION BOOKS LTD Imperial Works, Perren Street, London NW5 3ED www.prionbooks.com

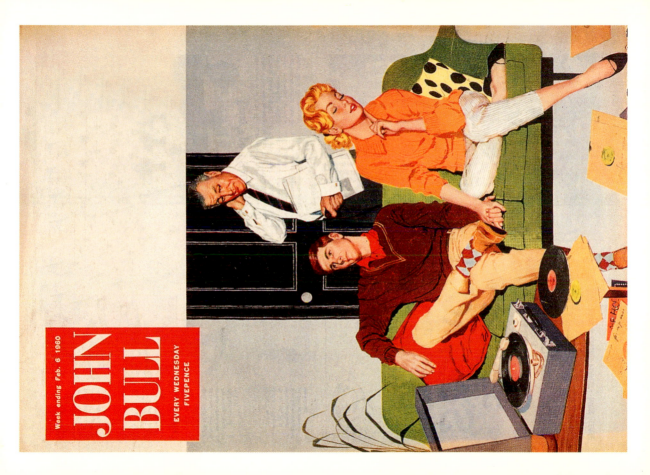

Week ending Feb. 6 1960

JOHN BULL

EVERY WEDNESDAY
FIVEPENCE

PRION

THE JOY OF PARENTING TODDLERS TO TEENAGERS FROM THE CLASSIC MAGAZINE ERA
PRION BOOKS LTD Imperial Works, Perren Street, London NW5 3ED www.prionbooks.com

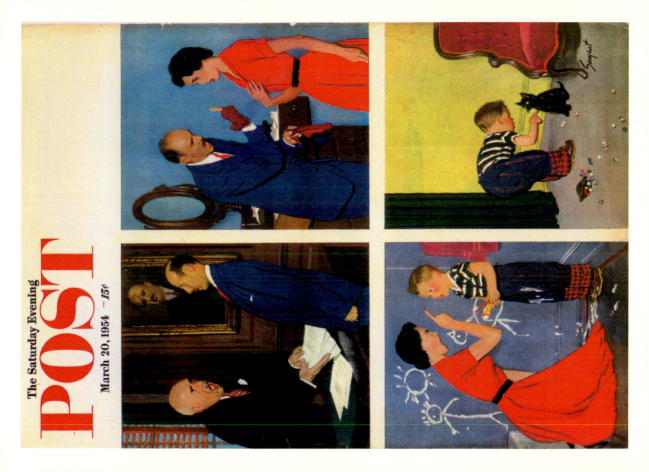

The Saturday Evening POST

March 20, 1954 — 15¢

PRION

THE JOY OF PARENTING TODDLERS TO TEENAGERS FROM THE CLASSIC MAGAZINE ERA
PRION BOOKS LTD Imperial Works, Perren Street, London NW5 3ED www.prionbooks.com

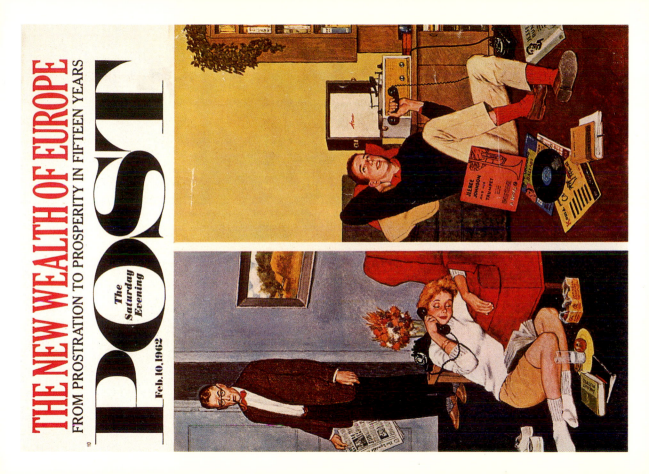

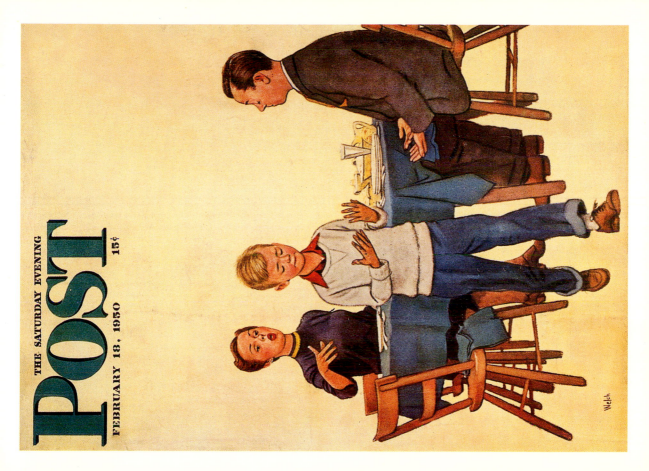

THE JOY OF PARENTING TODDLERS TO TEENAGERS FROM THE CLASSIC MAGAZINE ERA

PRION BOOKS LTD Imperial Works, Perren Street, London NW5 3ED www.prionbooks.com

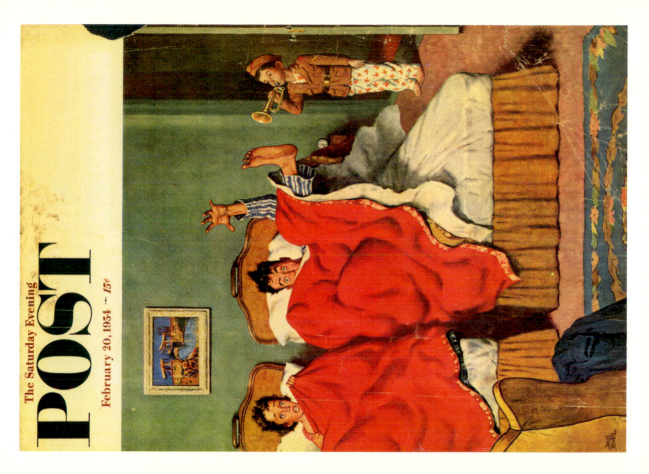

The Saturday Evening **POST**

February 20, 1954 — 15¢

PRION

THE JOY OF PARENTING TODDLERS TO TEENAGERS FROM THE CLASSIC MAGAZINE ERA
PRION BOOKS LTD Imperial Works, Perren Street, London NW5 3ED www.prionbooks.com

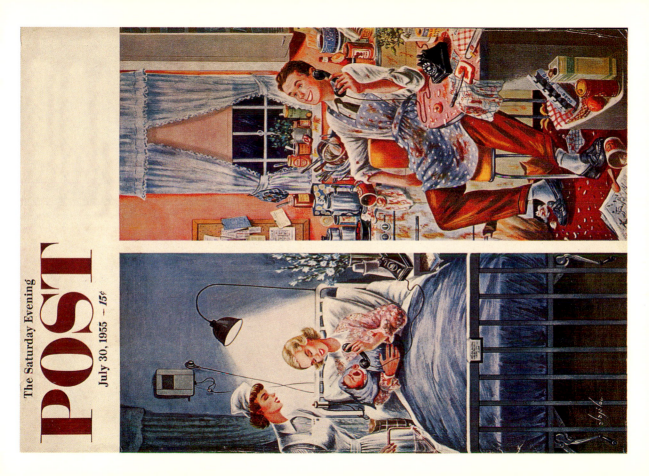

PRION

THE JOY OF PARENTING TODDLERS TO TEENAGERS FROM THE CLASSIC MAGAZINE ERA
PRION BOOKS LTD Imperial Works, Perren Street, London NW5 3ED www.prionbooks.com

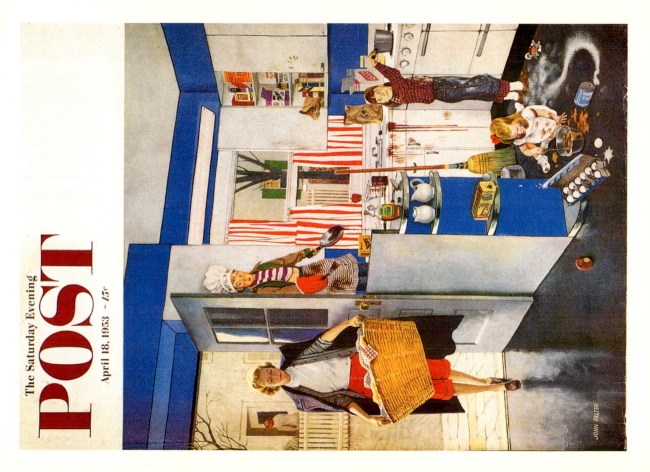

THE JOY OF PARENTING TODDLERS TO TEENAGERS FROM THE CLASSIC MAGAZINE ERA
PRION BOOKS LTD Imperial Works, Perren Street, London NW5 3ED www.prionbooks.com

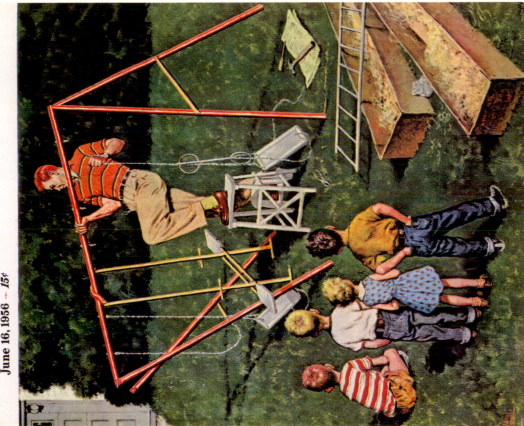

The Saturday Evening

POST

June 16, 1956 – 15¢

PRION

THE JOY OF PARENTING TODDLERS TO TEENAGERS FROM THE CLASSIC MAGAZINE ERA
PRION BOOKS LTD Imperial Works, Perren Street, London NW5 3ED www.prionbooks.com

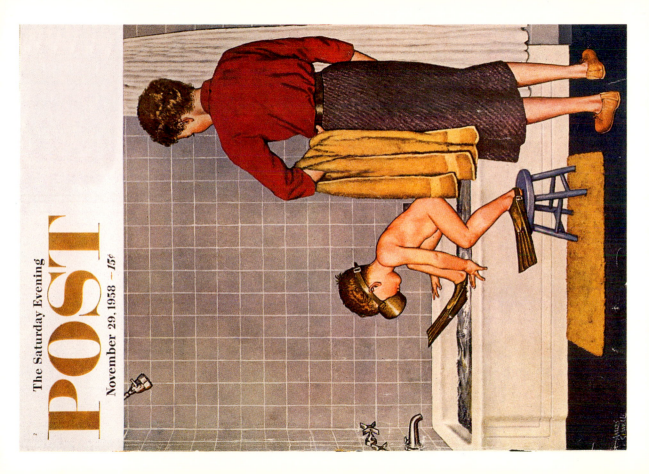

The Saturday Evening **POST** November 29, 1958 – 15¢

PRION

THE JOY OF PARENTING TODDLERS TO TEENAGERS FROM THE CLASSIC MAGAZINE ERA
PRION BOOKS LTD Imperial Works, Perren Street, London NW5 3ED www.prionbooks.com

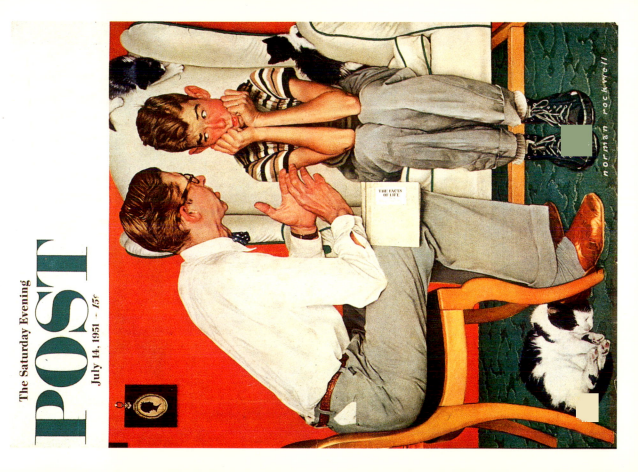

PRION

THE JOY OF PARENTING TODDLERS TO TEENAGERS FROM THE CLASSIC MAGAZINE ERA

PRION BOOKS LTD Imperial Works, Perren Street, London NW5 3ED www.prionbooks.com

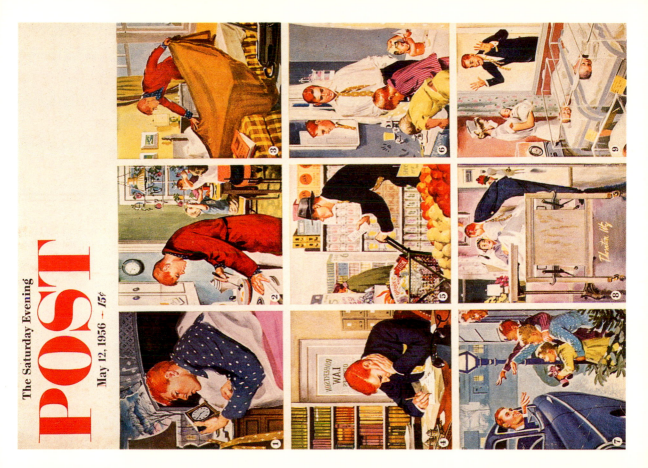

PRION

THE JOY OF PARENTING TODDLERS TO TEENAGERS FROM THE CLASSIC MAGAZINE ERA
PRION BOOKS LTD Imperial Works, Perren Street, London NW5 3ED www.prionbooks.com

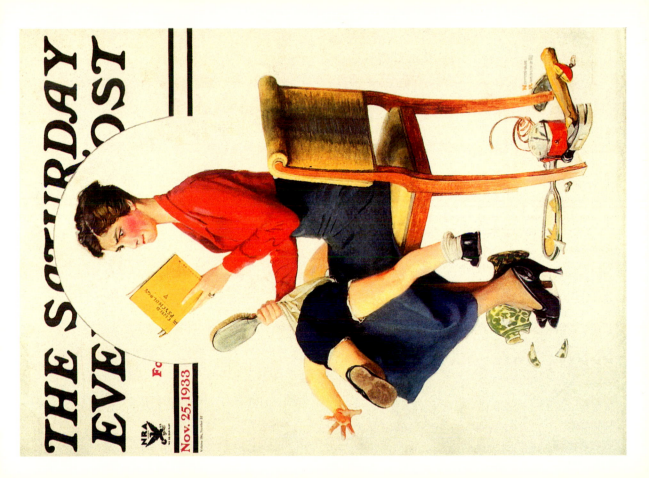

PRION

THE JOY OF PARENTING TODDLERS TO TEENAGERS FROM THE CLASSIC MAGAZINE ERA
PRION BOOKS LTD Imperial Works, Perren Street, London NW5 3ED www.prionbooks.com

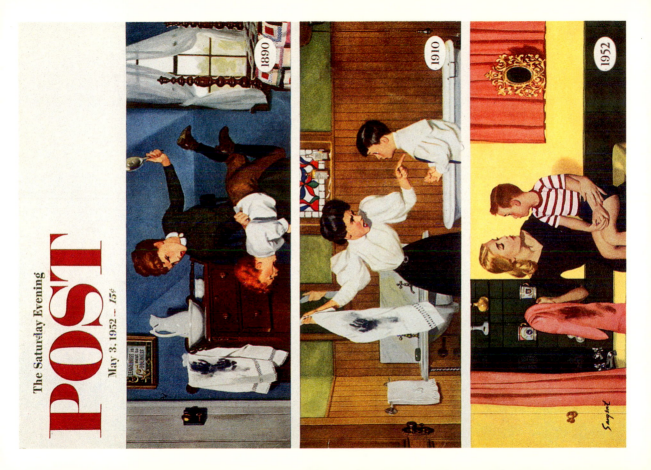

THE JOY OF PARENTING TODDLERS TO TEENAGERS FROM THE CLASSIC MAGAZINE ERA
PRION BOOKS LTD Imperial Works, Perren Street, London NW5 3ED www.prionbooks.com

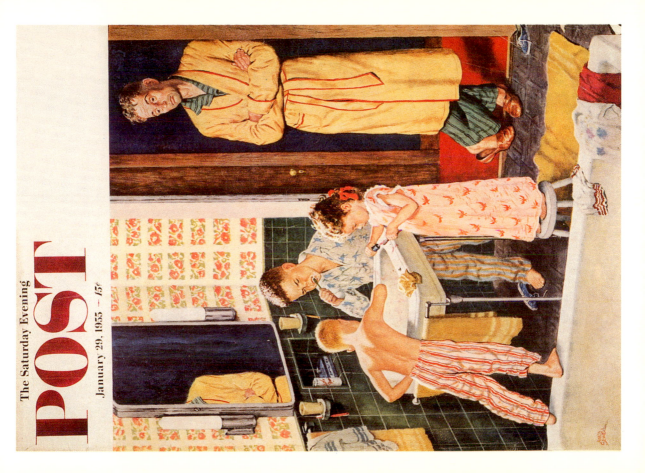

PRION

THE JOY OF PARENTING TODDLERS TO TEENAGERS FROM THE CLASSIC MAGAZINE ERA
PRION BOOKS LTD Imperial Works, Perren Street, London NW5 3ED www.prionbooks.com

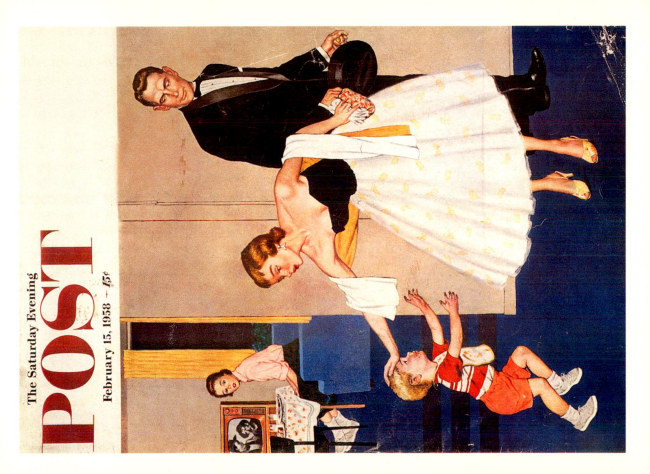

The Saturday Evening
POST
February 15, 1958 – 15¢

PRION

THE JOY OF PARENTING TODDLERS TO TEENAGERS FROM THE CLASSIC MAGAZINE ERA
PRION BOOKS LTD Imperial Works, Perren Street, London NW5 3ED www.prionbooks.com

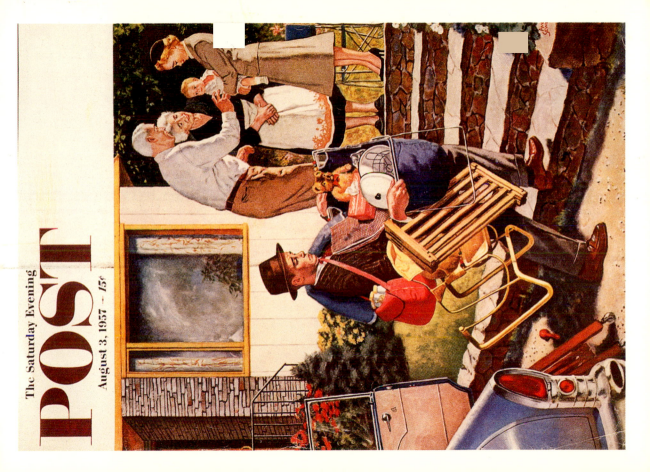

The Saturday Evening POST

August 3, 1957 — 15¢

THE JOY OF PARENTING TODDLERS TO TEENAGERS FROM THE CLASSIC MAGAZINE ERA

PRION BOOKS LTD Imperial Works, Perren Street, London NW5 3ED www.prionbooks.com

PRION

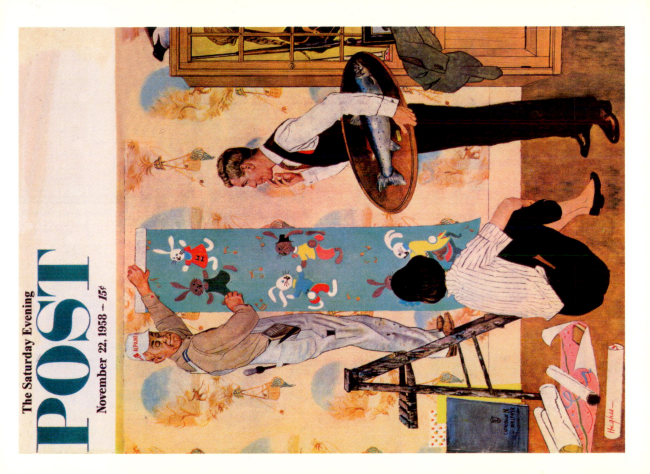

The Saturday Evening POST

November 22, 1958 — 15¢

THE JOY OF PARENTING TODDLERS TO TEENAGERS FROM THE CLASSIC MAGAZINE ERA
PRION BOOKS LTD Imperial Works, Perren Street, London NW5 3ED www.prionbooks.com

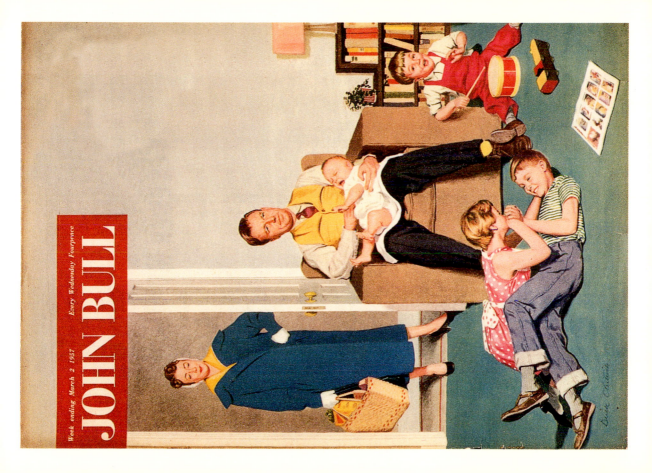

JOHN BULL

Every Wednesday Fourpence

Week ending March 2 1957

PRION

THE JOY OF PARENTING TODDLERS TO TEENAGERS FROM THE CLASSIC MAGAZINE ERA

PRION BOOKS LTD Imperial Works, Perren Street, London NW5 3ED www.prionbooks.com

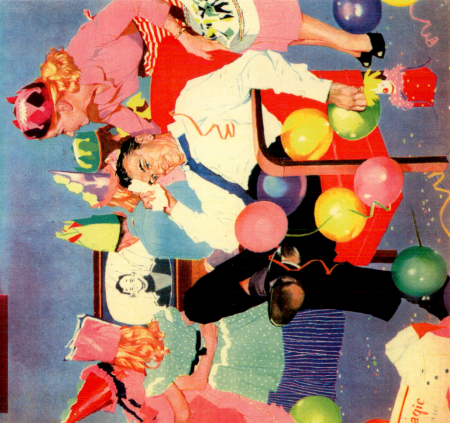

Week ending January 10 1959

JOHN BULL
ILLUSTRATED

EVERY WEDNESDAY 4½d

PRION

THE JOY OF PARENTING TODDLERS TO TEENAGERS FROM THE CLASSIC MAGAZINE ERA
PRION BOOKS LTD Imperial Works, Perren Street, London NW5 3ED www.prionbooks.com

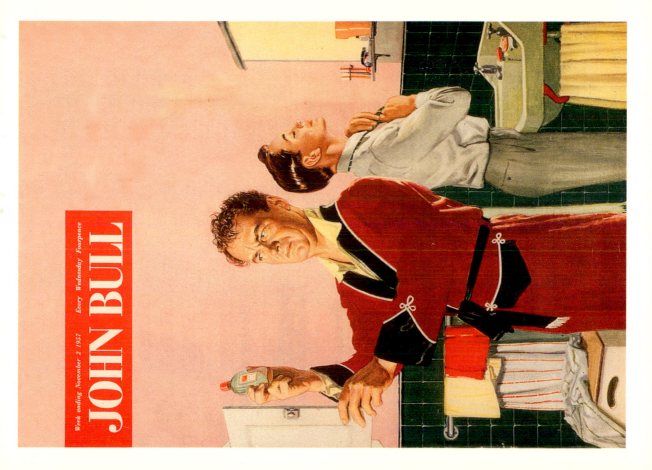

Week ending November 2 1957 Every Wednesday Fourpence

JOHN BULL

PRION

THE JOY OF PARENTING TODDLERS TO TEENAGERS FROM THE CLASSIC MAGAZINE ERA
PRION BOOKS LTD Imperial Works, Perren Street, London NW5 3ED www.prionbooks.com

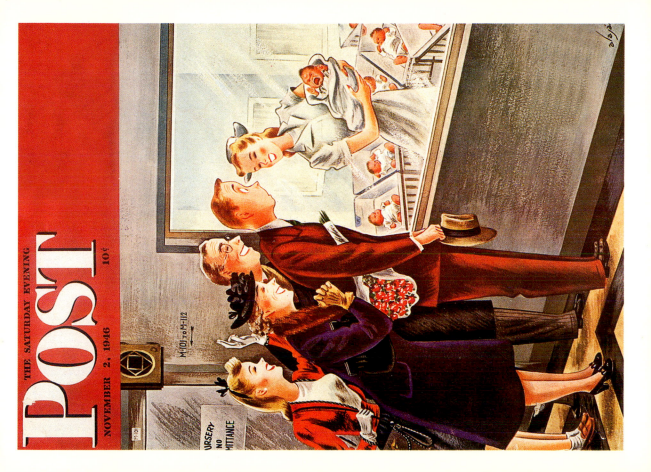

PRION

THE JOY OF PARENTING TODDLERS TO TEENAGERS FROM THE CLASSIC MAGAZINE ERA
PRION BOOKS LTD Imperial Works, Perren Street, London NW5 3ED www.prionbooks.com

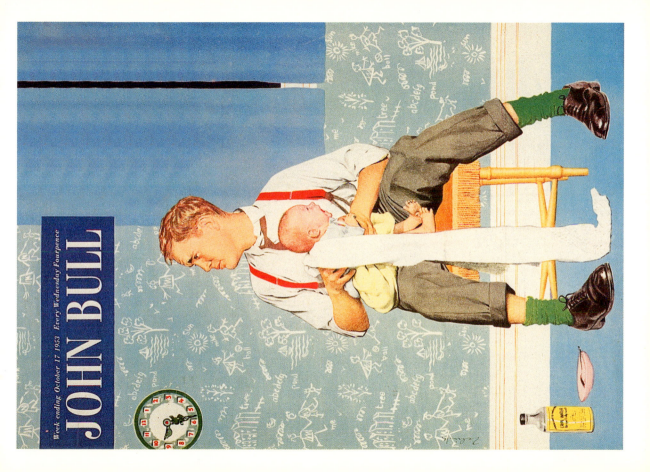

PRION

THE JOY OF PARENTING TODDLERS TO TEENAGERS FROM THE CLASSIC MAGAZINE ERA
PRION BOOKS LTD Imperial Works, Perren Street, London NW5 3ED www.prionbooks.com

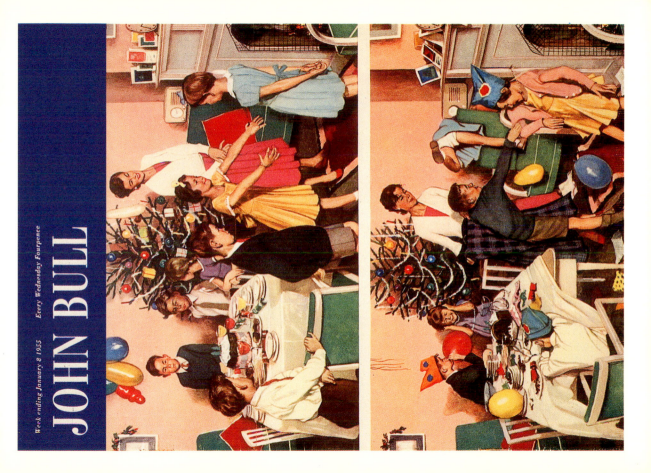

THE JOY OF PARENTING TODDLERS TO TEENAGERS FROM THE CLASSIC MAGAZINE ERA
PRION BOOKS LTD Imperial Works, Perren Street, London NW5 3ED www.prionbooks.com

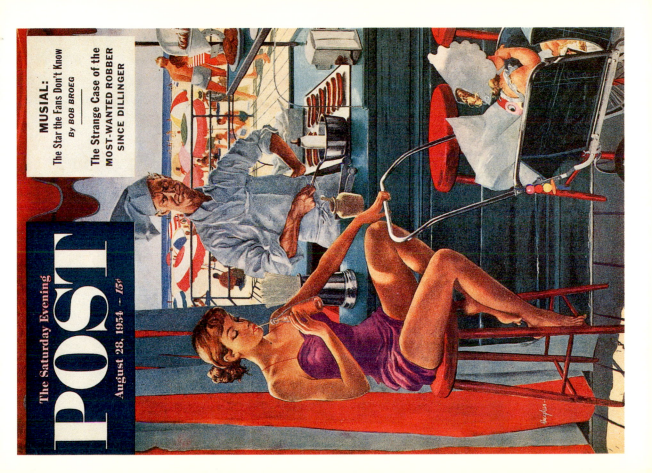

THE JOY OF PARENTING TODDLERS TO TEENAGERS FROM THE CLASSIC MAGAZINE ERA
PRION BOOKS LTD Imperial Works, Perren Street, London NW5 3ED www.prionbooks.com

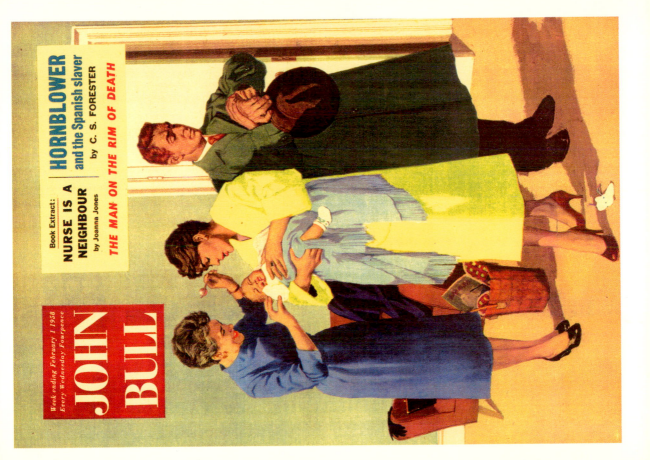

PRION

THE JOY OF PARENTING TODDLERS TO TEENAGERS FROM THE CLASSIC MAGAZINE ERA
PRION BOOKS LTD Imperial Works, Perren Street, London NW5 3ED www.prionbooks.com